前言
INTRODUCTION

Stuart Hamm(史都‧翰)生於1960年路易斯安那州，父親是位知名樂評人，並擔任音樂書籍主編及美國音樂協會創辦人，母親則是一位歌劇聲樂家，在充滿音樂環境下成長的Stuart，從小便由家人教導學習鋼琴與長笛，從爵士、古典到搖滾；從Miles Davis到歌劇…。1973年在拿到生平第一把Bass後，由於他自幼深厚的樂理基礎便自己摸索，高中時加入學校的爵士樂團彈奏貝斯。在偶然機會下聽到 Stanley Clarke 的作品後，Stuart 便下定決心要成為世界上貝斯彈奏速度最快的人。高中畢業後Stuart就讀美國音樂名校Berklee，並認識吉他教父Steve Vai，此時他開始研究如何將鋼琴雙聲部的彈奏方式運用到貝斯上，這對於往後他的音樂發展有著極大的影響。1978年在觀賞Jaco Pastorius與Weather Report的現場演出後，便徹底改變了他對貝斯的觀感及音樂喜好。在Berklee就讀幾個學期後，他便輟學跟著樂團巡迴表演。在好友Steve Vai邀請下，參與了Steve Vai首張專輯的錄製工作。之後又認識Steve的老師Joe Satriani，雖然Stuart是名Bass手，但是他的成名卻與吉他手有著息息相關的宿命，透過與這些吉他界大師合作，讓他名聲遠播，並為知名貝斯雜誌 Bass Player's 讀者票選為本世紀最偉大的Bass宗師之一。

本DVD為Stuart Hamm唯一一套中文影音教學DVD，內容從基礎樂理到進階技巧，包括：大小調音階、大小調和弦琶音、屬七和弦與琶音、大小調五聲音階、音階的連結、Slapping、Popping、Tapping…等學習電貝斯之基本技法，並附有5首Stuart現場表演+超級樂譜，全面性的影音教學，大幅提升您的彈奏能力。

本教材含有大量影音教學譜例，非一般同類教材所及。我們花了相當多的精力在整理這些譜例上，無非就是要讓此張教材不是一般看過就算了的影片，而是可以讓你一再反覆觀看、反覆練習之用，如果你了解此項功能，也能逐項練習，相信這套教材足足可以抵上你去找一個吉他老師上10堂課甚至更久的效果；其次，任何影音教材看久了總是會疲倦，建議你每次選取您需要的課程，配合書中譜例，熟練即可，按部就班達到吉他演奏的境界；再者，電貝斯技術非常廣泛，亦非一張光碟可以完全學完，建議您學時同時搭配其他技巧、樂理相關書籍，這樣有助於讓您更能體會貝斯技巧的奧秘之處；最後，感謝您購買本教材，並投入時間練習，如果您覺得此張DVD對你的技術很有幫助，希望您也能介紹給您的同好，讓更多人受惠，也祝各位琴藝進步。

LESSONS

05 **SESSION 1 | WARM UP** 熱手練習

Finger Stretch
手指的伸展

05 **SESSION 2 | BASIC SCALES & HARMONY** 基礎音階與和聲

Major Scale
大調音階

Minor Scale
小調音階

Major & Minor Pentatonic Scales
大、小調五聲音階

07 **SESSION 3 | CHORD & ARPEGGIOS** 和弦與琶音

Major 3rd & Minor 3rd Chord & Arpeggio
大三、小三和弦與琶音

Major & Minor 10ths
大調、小調和弦的十度音

Major 7thchord、Scale & Arpeggio
大七和弦、音階與琶音

Dominant 7th Chord、Scale、Arpeggio & Chord
屬七和弦、音階與琶音

Minor 7th Chord、Scale & Arpeggio
小七和弦、音階與琶音

16 **SESSION 4 | UP & DOWN THE NECK** 在琴頸上做上下移動

2 Octave Major & Minor Scale
二個八度的大、小調音階

Open Note Jumps
使用空弦音

Major 7th & Minor 7th & Dominant 7th With Open Strings
彈奏大七、小七與屬七和弦音階

CONTENTS

21 **SESSION 5 | SLAPPING & POPPING** 擊弦與扣弦

Thumb、Wrist and Finger Position
拇指，手腕和手指的位置

Popping
扣弦

Hammer-Ons
搥音

Left Hand Ghost Slaps
左手的幽靈音

Triplets W/Ghost Slaps
三連音加幽靈音的擊弦

Paradiddles
複合拍

25 **SESSION 6 | TAPPING** 點弦

Hand Position
手的位置

G Scale By Tapping
G大調的點弦

Two Hand Tapping
雙手點弦

「Sexually Active」 Opening
「Sexually Active」歌曲的開頭樂句

LIVE SONGS

28　Portugal Event

30　Terminal Beach

32　Prelude In C

34　Outbound

36　Jasmine（茉莉花）

電貝士常用符號技巧解說

音階圖

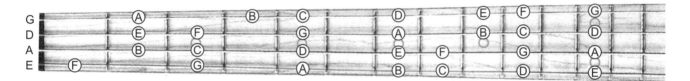

左右符號說明

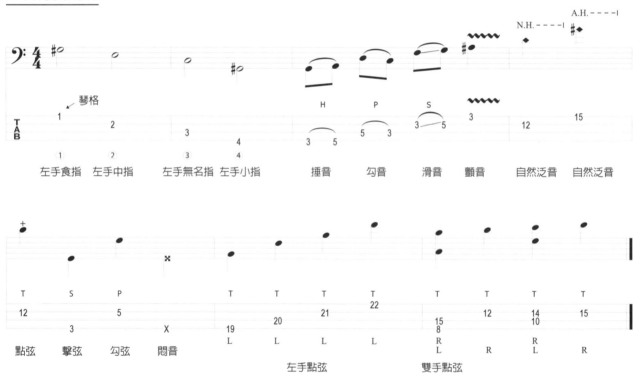

其他符號

‖: :‖	:	Repeat，反覆彈唱記號。
𝄋 或 *D.S.*	:	Da Sequne，從前面的 𝄋 處再彈一次。
⊕	:	Coda，跳至下一個Coda處彈奏至結束。
Fine	:	結束彈奏記號。
Rit	:	Ritardando，指速度漸次徐緩漸慢。
F.O.	:	Fade Out，聲音逐漸消失。

LESSONS

1 Warm Up
熱手練習

▶ Finger Stretch 手指的伸展

EXAMPLE 1　Warm Up

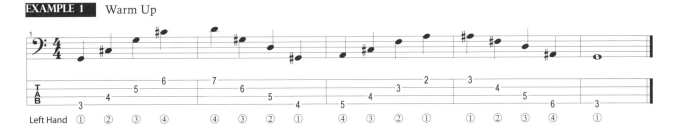

2 Basic Scales & Harmony
基礎音階與和聲

▶ Major Scale 大調音階

EXAMPLE 1　G Major Scale

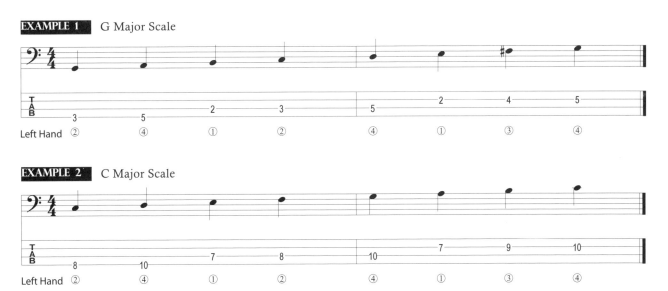

EXAMPLE 2　C Major Scale

▶ Minor Scale小調音階

EXAMPLE 1　G Minor Scale

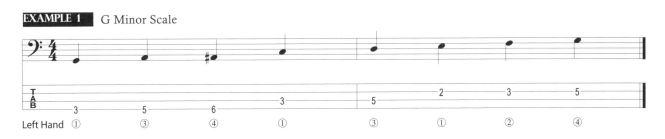

EXAMPLE 2 C Minor Scale

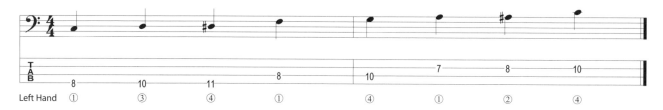

▶ Major & Minor Pentatonic Scales 大、小調五聲音階

EXAMPLE 1 G Major Patatonic Scale

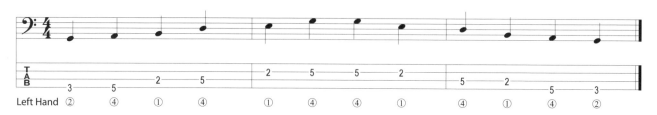

EXAMPLE 2 C Major Patatonic Scale

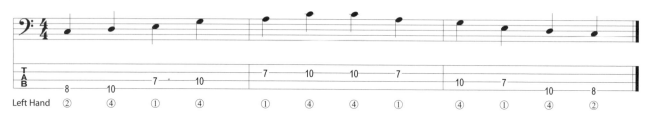

EXAMPLE 3 G Minor Patatonic Scale

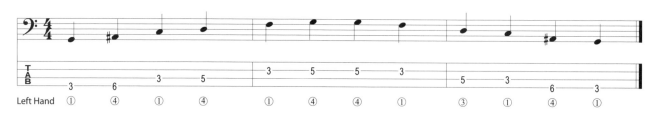

EXAMPLE 4 C Minor Patatonic Scale

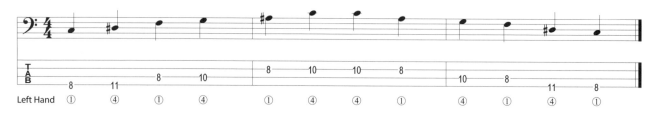

LESSONS

Session 3 **Chord & Arpeggios**
和弦與琶音

▶ Major 3rd & Minor 3rd Chord & Arpeggio　大三、小三和弦與琶音

EXAMPLE 1　G Major Arpeggio

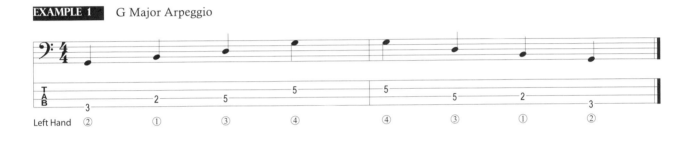

EXAMPLE 2　C Major Arpeggio

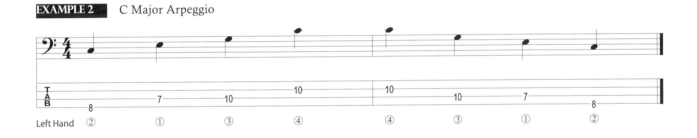

EXAMPLE 3　G Minor Arpeggio

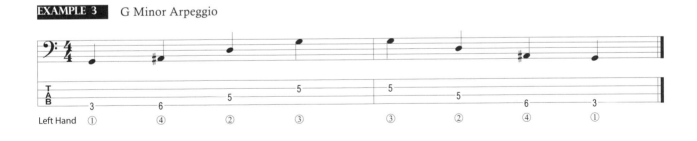

EXAMPLE 4　C Minor Arpeggio

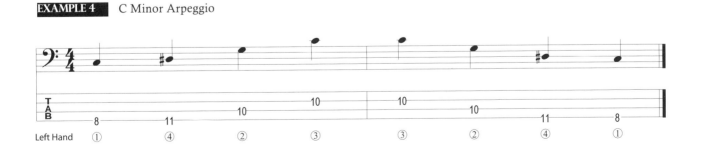

7

EXAMPLE 5 G Major Scale + G Major Arpeggio

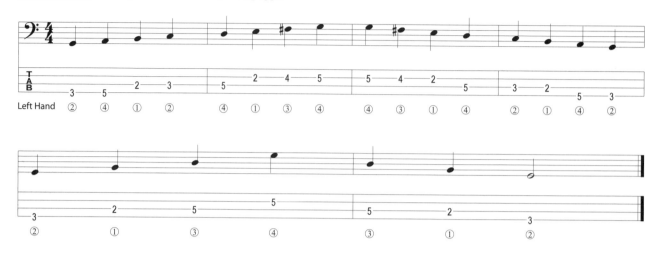

EXAMPLE 6 C Major Scale + C Major Arpeggio

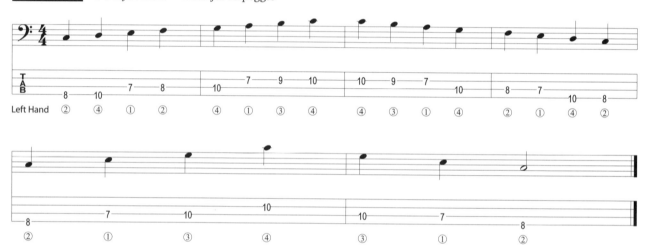

EXAMPLE 7 G Minor Scale + G Minor Arpeggio

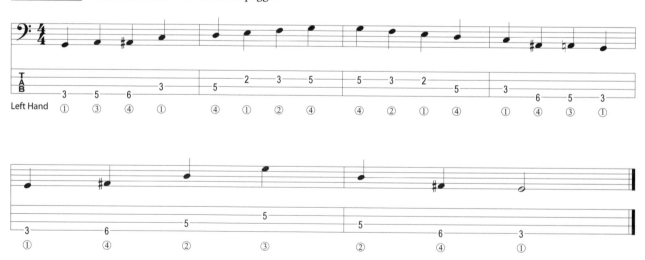

EXAMPLE 8 C Minor Scale + C Minor Arpeggio

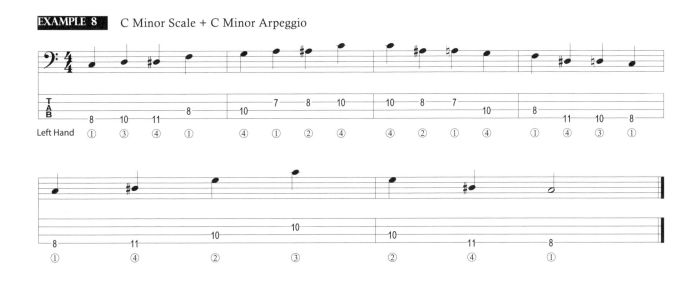

▶ Major & Minor 10ths　大調、小調和弦的十度音

EXAMPLE 1 Gm Cm Am Dm G C A D Chord

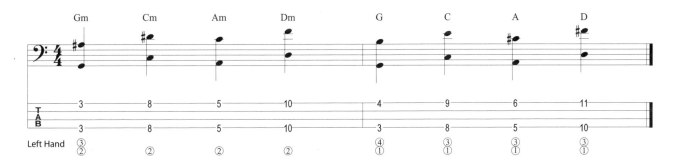

EXAMPLE 2 G Major Scale + Chord + G Arpeggio

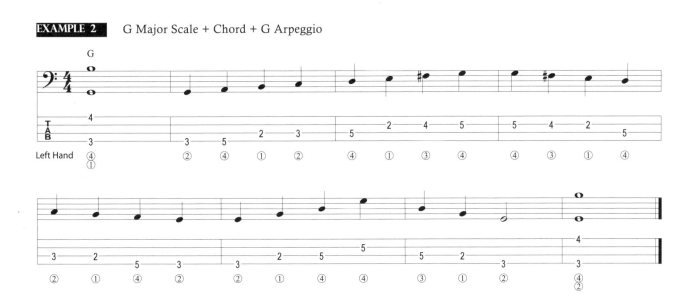

EXAMPLE 3 G Minor Scale + Chord + G Arpeggio

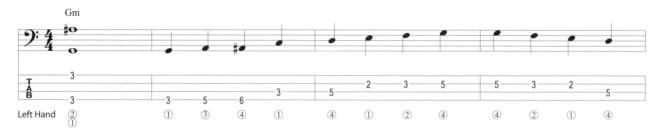

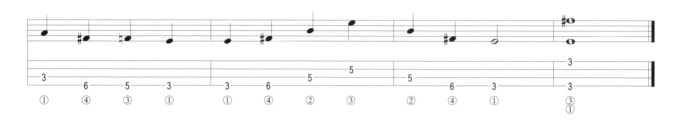

EXAMPLE 4 C Minor Scale + Chord + C Arpeggio

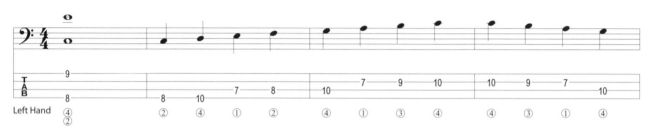

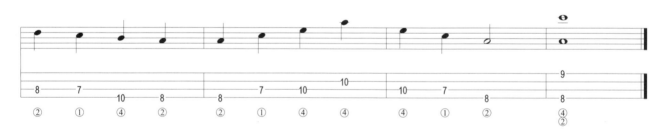

EXAMPLE 5 Cminor Scale + Chord + C Arpeggio

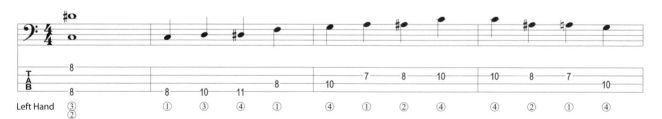

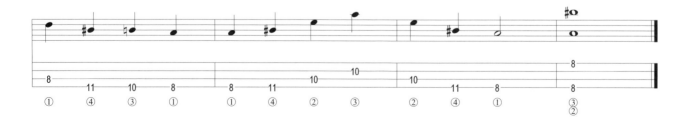

▶ Major 7th chord、Scale & Arpeggio 大七和弦、音階與琶音

EXAMPLE 1 G Major 7

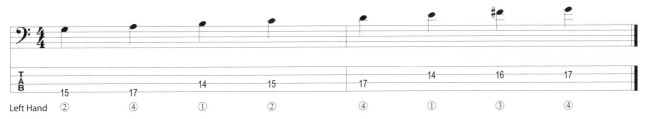

EXAMPLE 2 G Major 7 Arpeggio

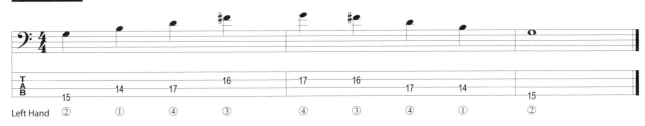

EXAMPLE 3 G Major 7 + G Major7 Arpeggio

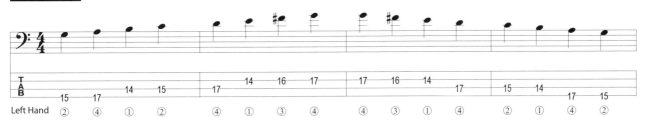

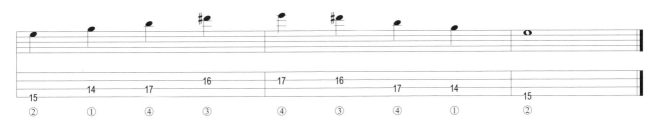

EXAMPLE 4 Cmajor 7 + G Major 7 Chord

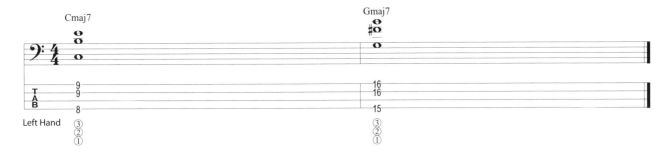

EXAMPLE 5 G Major 7 Chord + G Major 7 Arpeggio

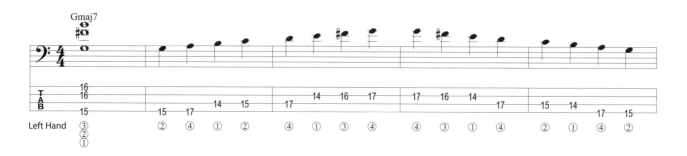

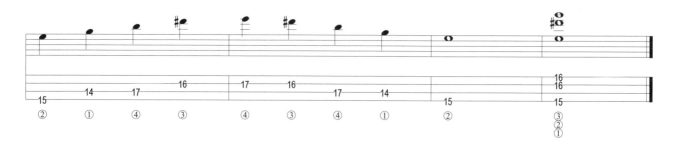

EXAMPLE 6 C Major 7 Chord + C Major7 Arpeggio

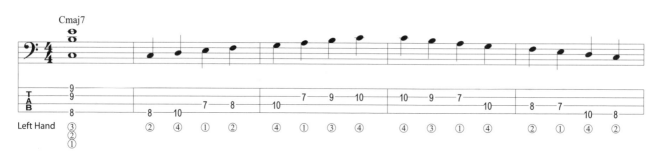

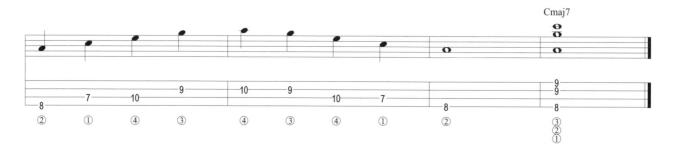

▶ Dominant 7th Chord、Scale、Arpeggio & Chord　屬七和弦、音階與琶音

EXAMPLE 1　G7

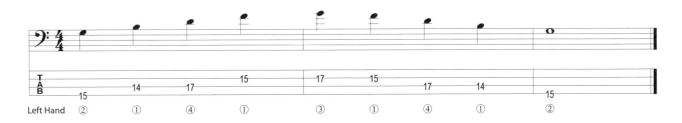

EXAMPLE 2　G7 Chord + G7 Arpeggio

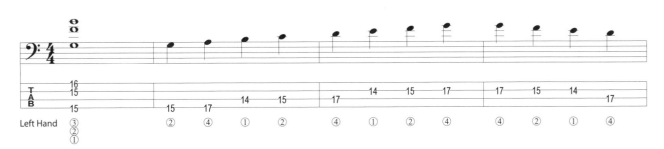

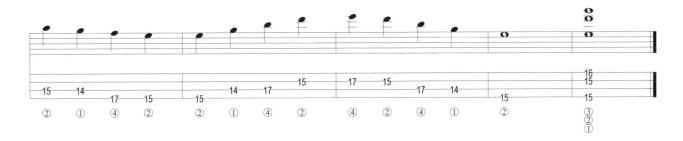

EXAMPLE 3　C7 Chord + C7 Arpeggio

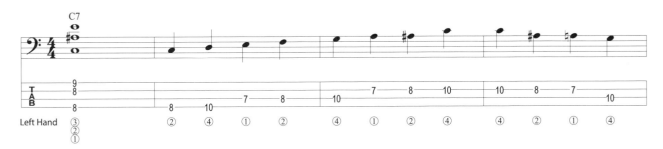

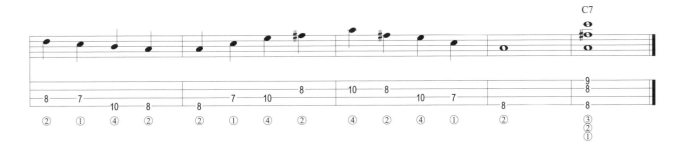

EXAMPLE 4 D7 + G7 + Arpeggio

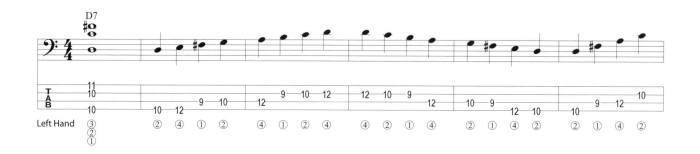

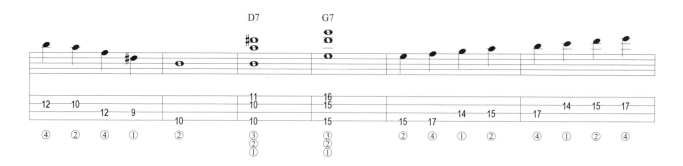

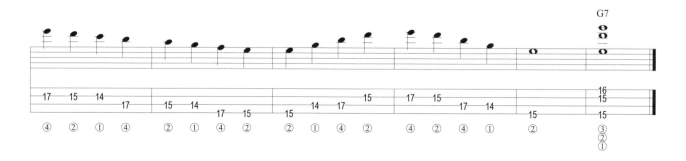

▶ Minor 7th Chord、Scale & Arpeggio 小七和弦、音階與琶音

EXAMPLE 1 Gm7 Chord + Arpeggio

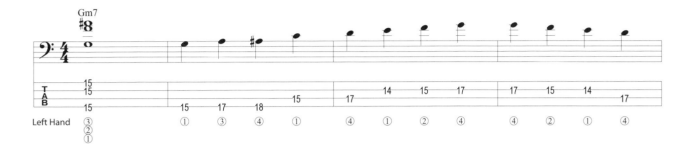

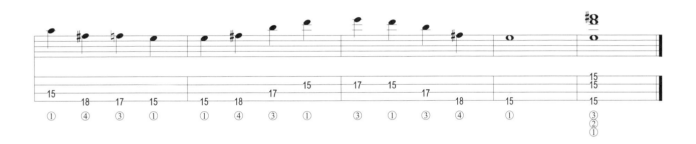

EXAMPLE 2 Cm7 Chord + Arpeggio

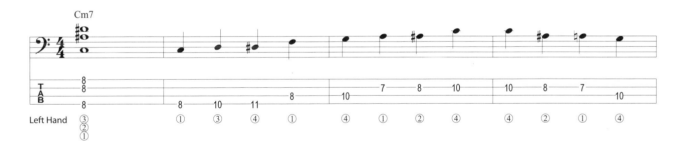

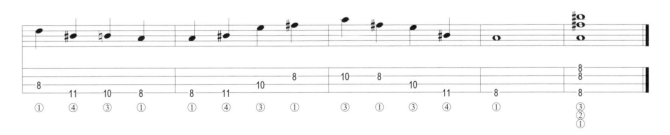

LESSONS

Up & Down The Neck
在琴頸上做上下移動

▶ 2 Octave Major & Minor Scale　二個八度的大、小調音階

EXAMPLE 1　G Major Scale

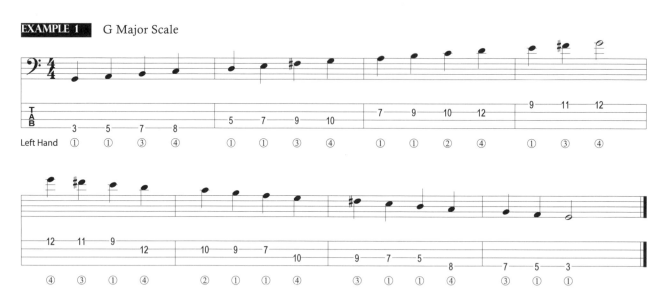

EXAMPLE 2　G Major Scale

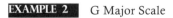

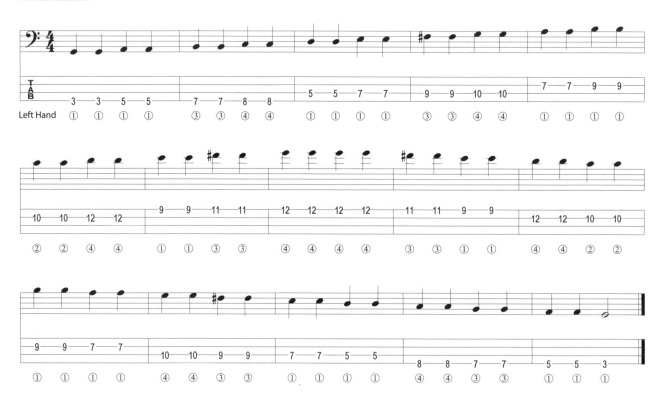

EXAMPLE 3 G Major Scale

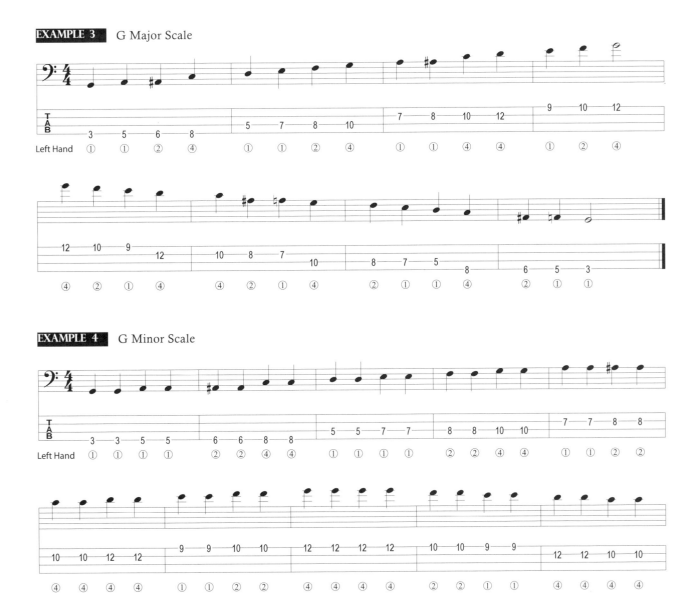

EXAMPLE 4 G Minor Scale

▶ Open Note Jumps 使用空弦音

EXAMPLE 1 G Major Arpeggio With Open String

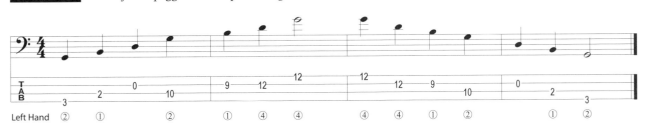

EXAMPLE 2 C Major Arpeggio With Open String

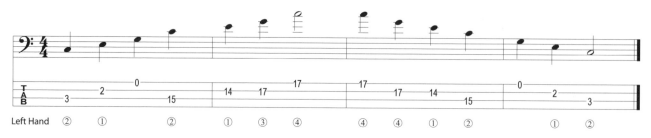

Left Hand ② ① ② ① ③ ④ ④ ④ ① ② ① ②

EXAMPLE 3 G Minor Arpeggio With Open String

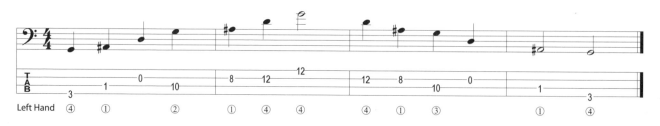

Left Hand ④ ① ② ① ④ ④ ④ ① ③ ① ④

EXAMPLE 4 C Minor Arpeggio With Open String

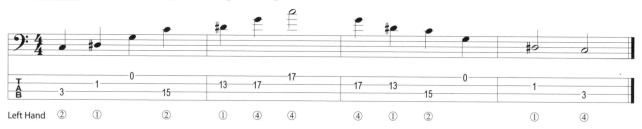

Left Hand ② ① ② ① ④ ④ ④ ① ② ① ④

EXAMPLE 5 G → C → Gm → Cm

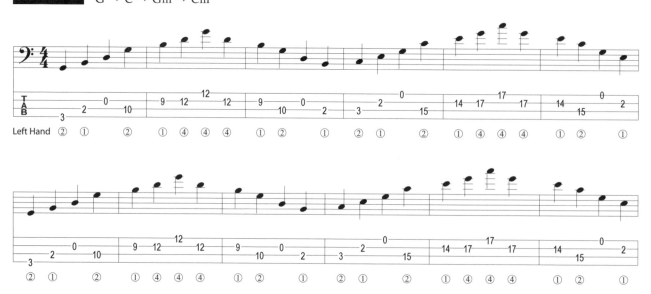

Left Hand ② ① ② ① ④ ④ ④ ① ② ① ② ① ② ① ④ ④ ④ ① ② ①

② ① ② ① ④ ④ ④ ① ② ① ② ① ② ① ④ ④ ④ ① ② ①

18

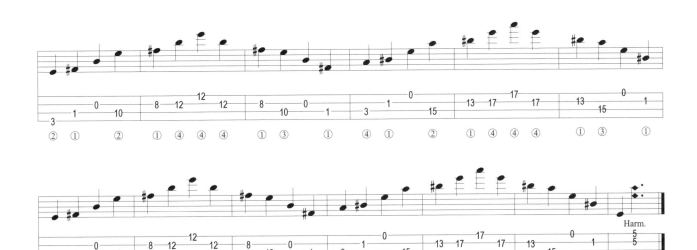

▶ Major 7th & Minor 7th & Dominant 7th With Open Strings　彈奏大七、小七與屬七和弦音階

EXAMPLE 1　G Major7 Arpeggio With Open Strings

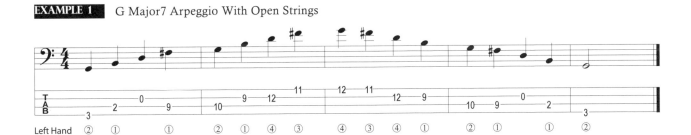

EXAMPLE 2　C Major7 Arpeggio With Open Strings

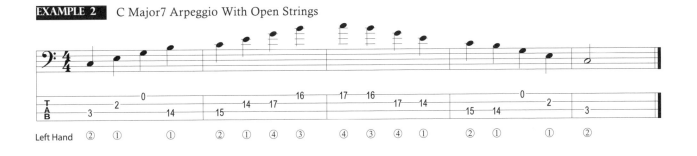

EXAMPLE 3　G7 Arpeggio With Open Strings

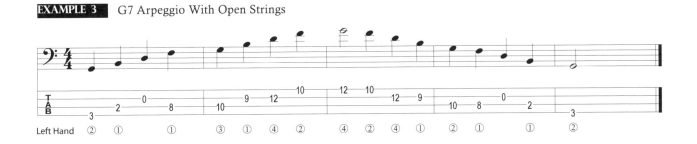

EXAMPLE 4 C7 Arpeggio With Open Strings

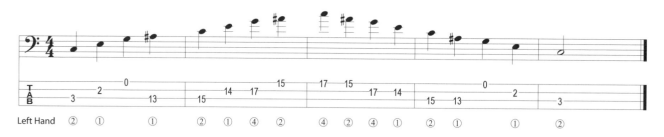

EXAMPLE 5 Gm7 Arpeggio With Open Strings

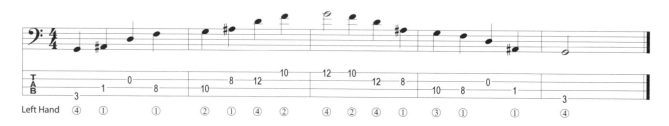

EXAMPLE 6 Cm7 Arpeggio With Open Strings

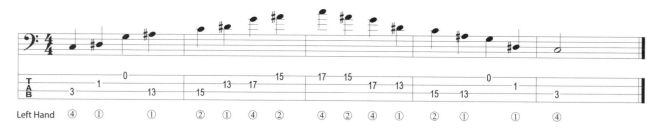

LESSONS

Session
5 | Slapping & Popping
擊弦與拘弦

▶ Thumb、Wrist and Finger Position 拇指、手腕和手指的位置

EXAMPLE 1 Slap

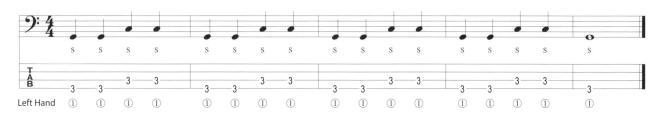

▶ Popping 拘弦

EXAMPLE 1 Slap + Popping

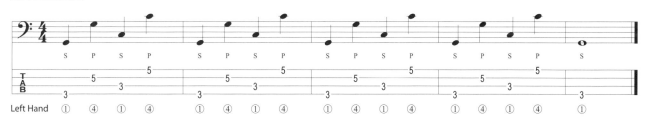

▶ Hammer-Ons 搥音

EXAMPLE 1 E Minor Petatonic Scale

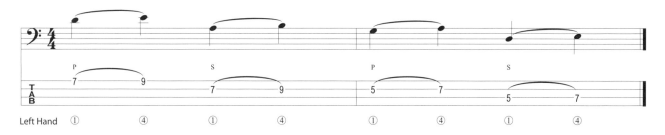

EXAMPLE 2 G Minor Petatonic Scale

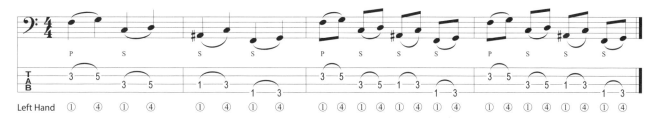

▶ Left hand ghost slaps　左手的幽靈音

EXAMPLE 1　D7 Slap

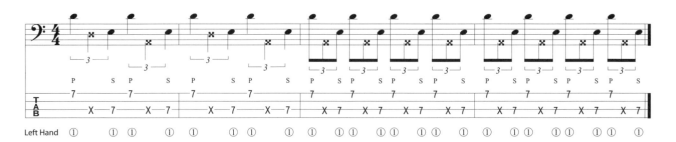

▶ Triplets W/Ghost Slaps　三連音加幽靈音的擊弦

EXAMPLE 2　Slap

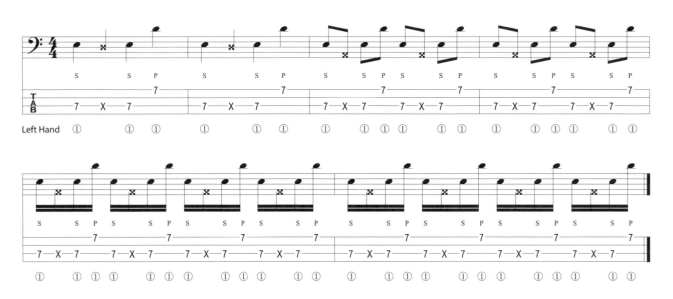

EXAMPLE 1　Slap

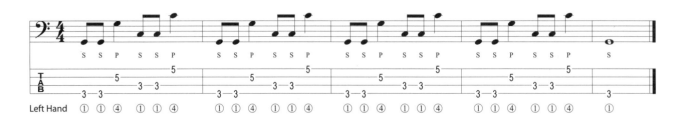

22

EXAMPLE 2 Slap

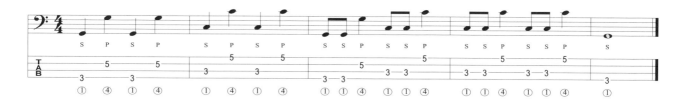

EXAMPLE 3 Slap

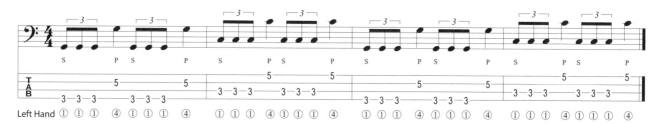

EXAMPLE 4 Slap

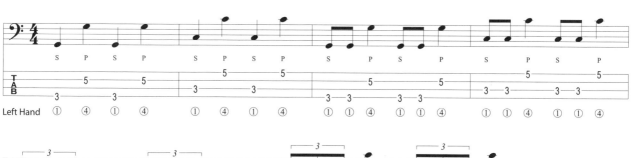

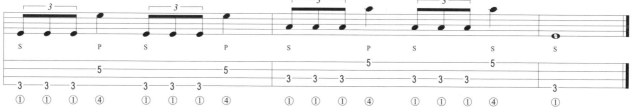

▶ Paradiddles 複合拍

EXAMPLE 1 Popping & Slapping

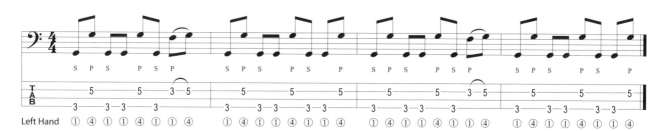

23

EXAMPLE 2 Popping & Slapping

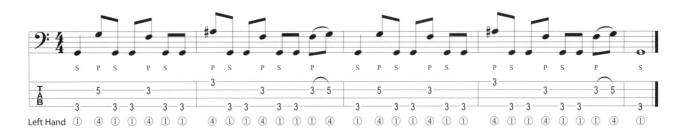

EXAMPLE 3 E Minor Petatonic

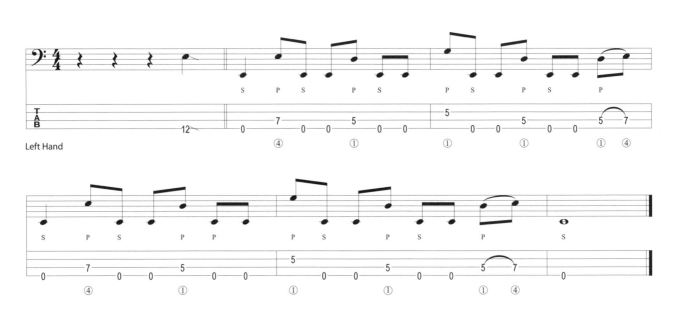

LESSONS

6 Tapping
點弦

▶ Hand Position 　手的位置

EXAMPLE 1 　Tapping

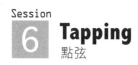

▶ G Scale By Tapping 　G大調的點弦

EXAMPLE 1 　Tapping

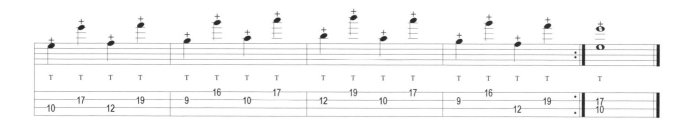

▶ Two Hand Tapping 　雙手點弦

EXAMPLE 1 　Tapping

EXAMPLE 2 Tapping

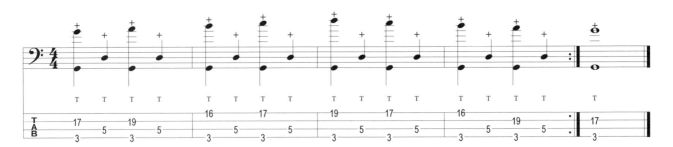

EXAMPLE 3 Tapping

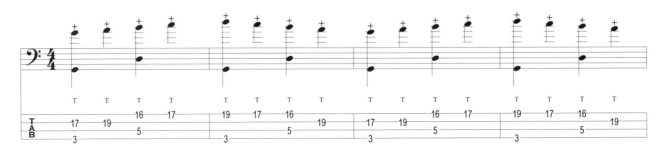

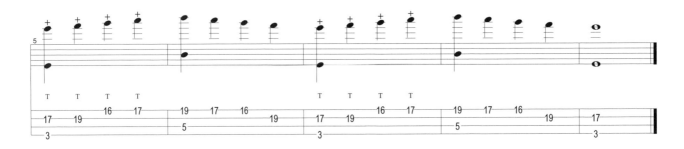

▶ 「Sexually Active」Opening 「Sexually Active」歌曲的開頭樂句

EXAMPLE 1 Tapping

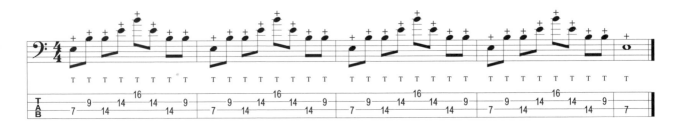

EXAMPLE 2 Tapping

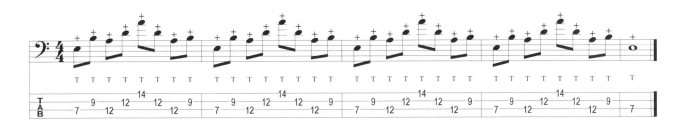

EXAMPLE 3 Tapping

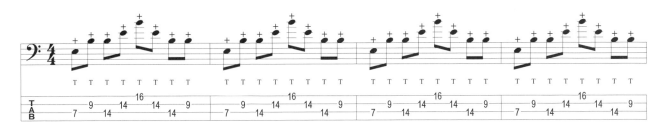

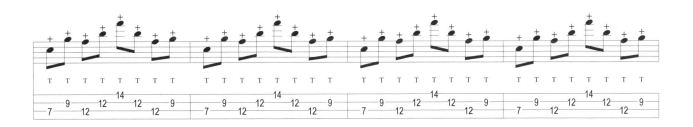

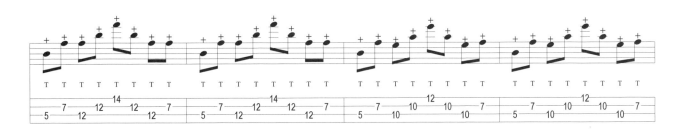

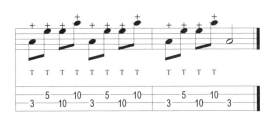

Portugal Event

Transcribed by Stuart Hamm

Music by Stuart Hamm
Arranged by Stuart Hamm

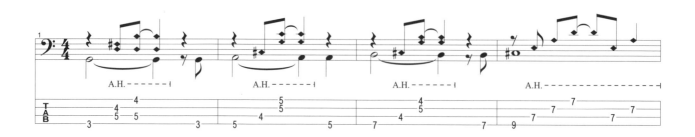

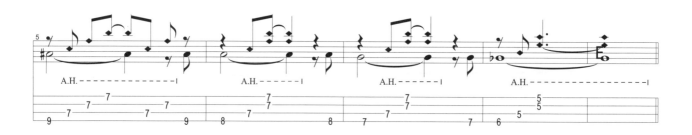

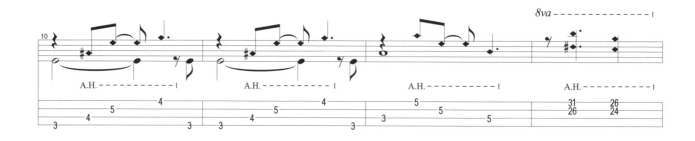

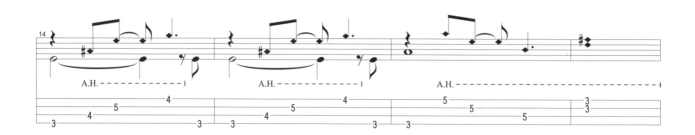

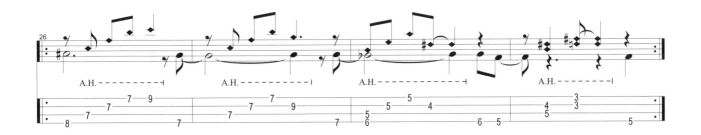

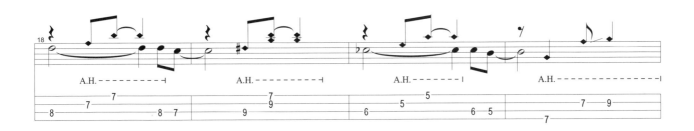

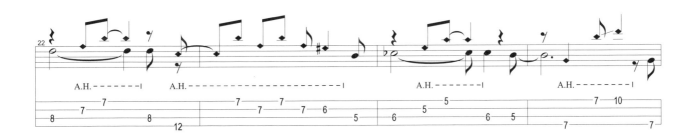

Terminal Beach

Transcribed by Stuart Hamm

Music by Stuart Hamm
Arranged by Stuart Hamm

右手

左手

右手

左手

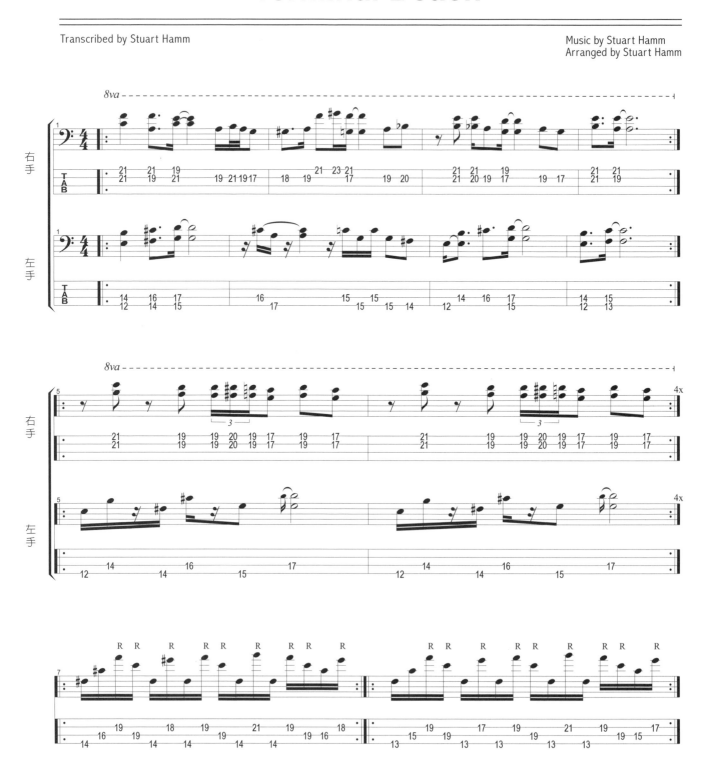

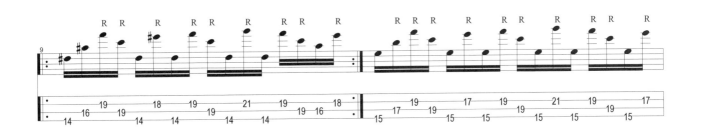

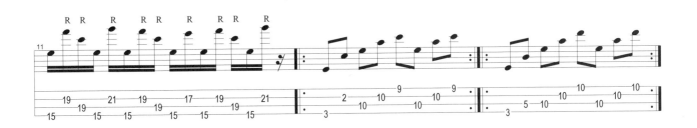

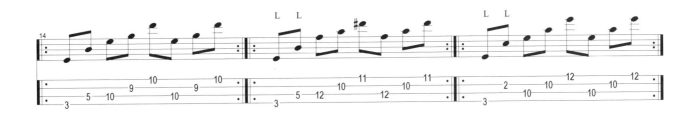

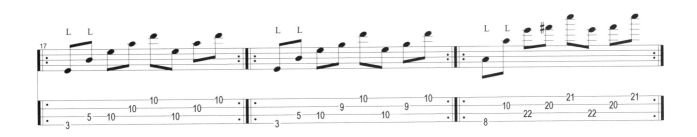

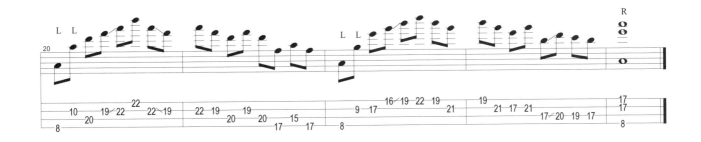

Prelude In C

Transcribed by Stuart Hamm

Music by Stuart Hamm
Arranged by Stuart Hamm

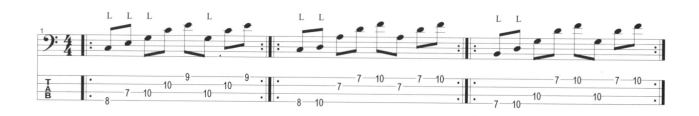

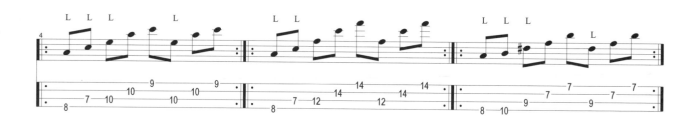

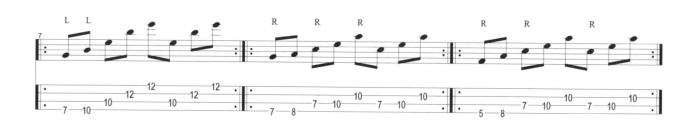

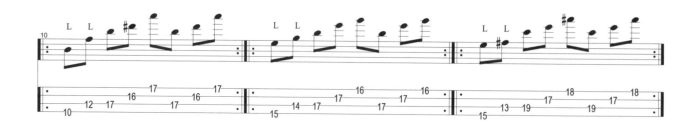

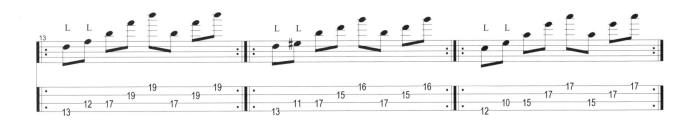

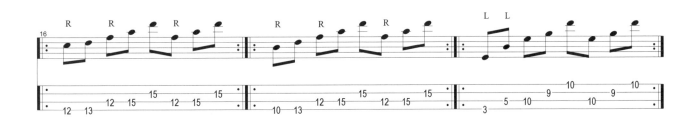

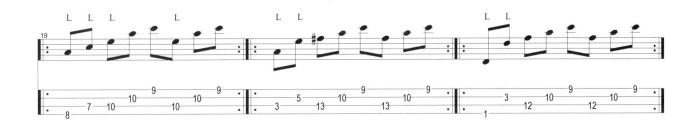

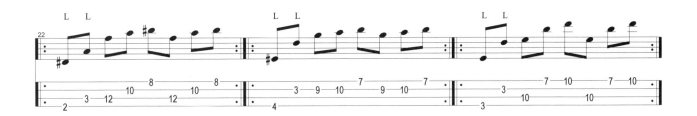

Outbound

Transcribed by Stuart Hamm

Music by Stuart Hamm
Arranged by Stuart Hamm

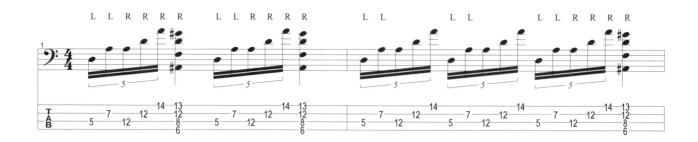

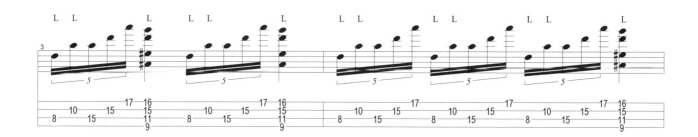

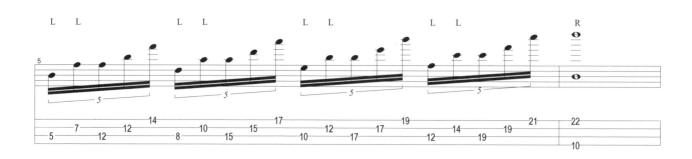

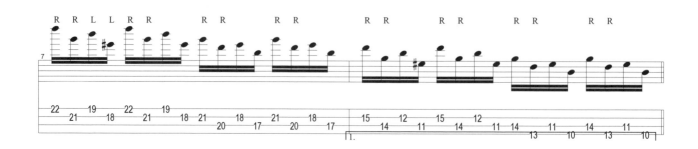

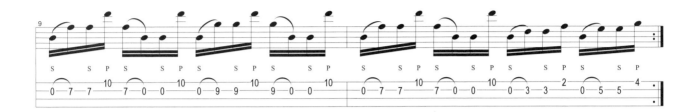

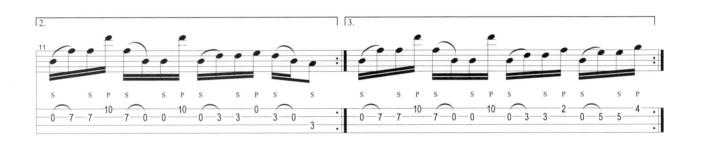

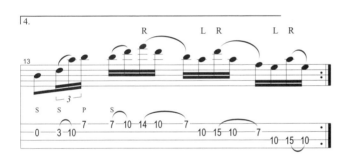

Jasmine（茉莉花）

Transcribed by Stuart Hamm

Music by Stuart Hamm
Arranged by Stuart Hamm

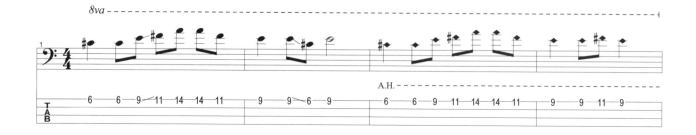

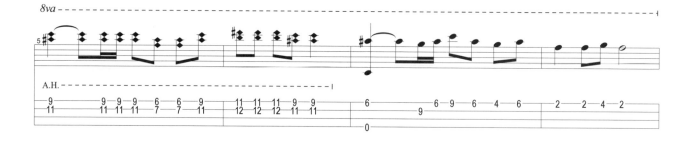

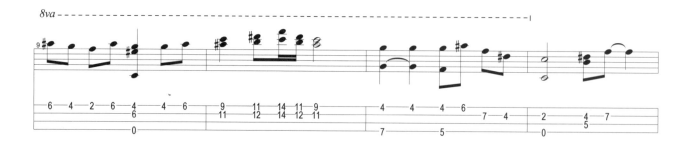

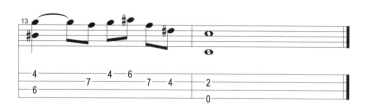

企劃製作	麥書國際文化事業有限公司
監製	潘尚文
編著	Stuart Hamm
拍攝統籌	吳怡慧
封面設計	徐翊鈞、沈育姍
美術編輯	沈育姍
影像拍攝	陳韋達、李國華
影音剪輯	徐翊鈞
樂譜編採	潘尚文、甯子達
譜面輸出	陳韋達
教學演奏	Stuart Hamm
錄音混音	林聰智
文字翻譯	陳宜娟、朱怡潔
文字校對	吳怡慧
特別感謝	搖滾帝國、海國樂器

出版 / 發行	麥書國際文化事業有限公司
地址	106臺北市辛亥路一段40號4樓
電話	886-2-23636166 / 886-2-23659859
傳真	886-2-23627353
印刷	鼎易印刷事業股份有限公司
法律顧問	聲威法律事務所
郵政劃撥	17694713
登記號	行政院新聞局局版台業第6074號
廣告回函	台灣北區郵政管理局登記證第12974號
ISBN	978-957-825-596-8
戶名	麥書國際文化事業有限公司
網址	www.musicmusic.com.tw
E-mail	vision.quest@msa.hinet.net

Stuart Hamm
THE GROOVE

中華民國九十六年 四月 初版

24H傳真訂購專線
（02）23627353

讀者回函

THE GROOVE
STUART HAMM

感謝您購買本書！為加強對讀者提供更好的服務，請詳填以下資料，寄回本公司，您的資料將立刻列入本公司優惠名單中，並可得到日後本公司出版品之各項資料，及意想不到的優惠哦！

| 姓名 _____ 生日 ___/___/___ 性別 □男 □女 |
| 電話 _____ E-mail _____ |
| 地址 _____ 機關學校 _____ |

01. 請問您曾經學過的樂器有哪些？
□ 鋼琴　　　□ 吉他　　　□ 弦樂　　　□ 管樂　　　□ 國樂　　　□ 其他_____

02. 請問您是從何處得知本書？
□ 書店　　　□ 網路　　　□ 社團　　　□ 樂器行　　　□ 朋友推薦　　　□ 其他_____

03. 請問您是從何處購得本書？
□ 書店　　　□ 網路　　　□ 社團　　　□ 樂器行　　　□ 郵政劃撥　　　□ 其他_____

04. 請問您認為本書的難易度如何？
□ 難度太高　　　□ 難易適中　　　□ 太過簡單

05. 請問您認為本書整體看來如何？
□ 棒極了　　　□ 還不錯　　　□ 遜斃了

06. 請問您認為本書的售價如何？
□ 便宜　　　□ 合理　　　□ 太貴

07. 請問您最喜歡本書的哪些部份？（可複選）
□ LESSONS　　□ LIVE SONGS　　□ 樂譜　　□ 美術設計　　□ 其他_____

08. 請問您認為本書還需要加強哪些部份？（可複選）
□ 教學內容　　□ 拍攝剪輯　　□ 影音光碟品質　　□ 美術設計　　□ 銷售通路　　□ 其他_____

09. 請問您希望未來公司為您提供哪方面的出版品？

非常感謝您填寫本表格，我們將極慎重的考慮您的意見，並立即將您的資料建檔。謝謝！

請沿虛線剪下寄回

www.musicmusic.com.tw

寄件人＿＿＿＿＿＿＿＿＿＿＿＿＿

地　址 ☐☐☐ ＿＿＿＿＿＿＿＿＿＿＿

＿＿＿＿＿＿＿＿＿＿＿＿＿＿＿＿＿

廣　告　回　函
台灣北區郵政管理局登記證
北台字第12974號

郵資已付 免貼郵票

麥書國際文化事業有限公司
106　台北市辛亥路一段40號4樓
4F,No.40,Sec.1,
Hsin-hai Rd.,Taipei Taiwan 106 R.O.C.

為加速郵件處理 ・ 請勿使用訂書針